The Beginner's Book of

OIL PAINTING

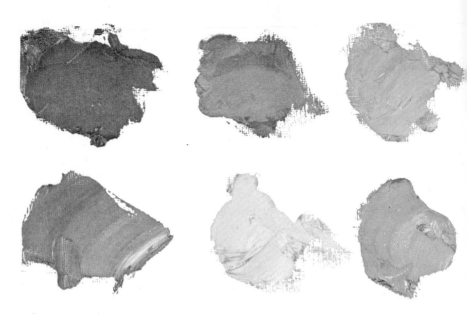

Surface quality and texture achieved by the use of a palette-knife in colour mixing

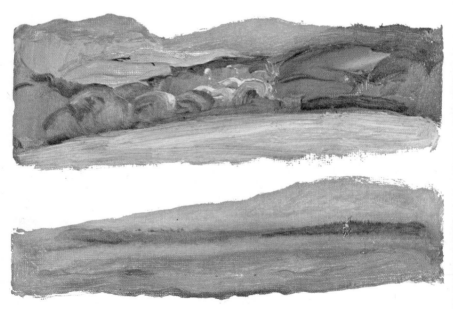

Colour schemes achieved with the mixtures above, and painted with the palette-knife

The Beginner's Book of

OIL PAINTING

written and illustrated by
ADRIAN HILL
P.P.R.O.I., R.B.A.

BLANDFORD PRESS
POOLE DORSET

© *Blandford Press Ltd*, 1958, 1977
Link House, West Street,
Poole, Dorset BH15 1LL

First published 1958
Second impression 1959
Third impression 1960
Fourth impression 1961
Fifth impression 1963
Sixth impression 1965
Seventh impression 1966
Eighth impression 1968
Ninth impression 1971
Tenth impression 1974
Eleventh impression 1977
Twelfth impression 1979

DEDICATION
For my God-daughter
AMANDA FAITLOUGH
when she first takes
up her brush

ISBN 0 7137 0020 3

Printed in Great Britain by
Butler & Tanner Ltd,
Frome and London

Contents

Light folding sketching easel

Introduction

SHALL I be accused of wishful thinking if I promise the reader that oil painting is not all that difficult? As a medium, it is, in my opinion, far easier and more straightforward than pure watercolour painting, as so many amateurs have discovered when, in despair, they have switched from one technique to the other.

For whereas transparent watercolour painting is often admitted by professionals to be a matter of hit or miss, and only expert skill can "score a hit", oil painting is a medium in which mistakes can be corrected, by painting over or scraping out and repainting, until something of the required result is achieved. I don't say that these various expedients are easy in themselves and I'm not promising that the finished picture will be free from obvious toil and perhaps tears, but I do say that there are far more legitimate devices by which you can redeem an oil painting that has got "stuck" than ever there are when a watercolour starts going wrong!

And during each stage you will be learning *how to paint*, the right way of mixing your colours and the best method of applying them—in short the mechanics of the craft—so that you can presently concentrate on the way that *you* as an individual—and this is all important—can best develop a personal technique, for in the last analysis, it is this which will mark out your paintings as different from the rest.

AUTHOR'S WARNING

In the following chapters I shall be giving you many hints and warnings which you will have possibly read before and perhaps already accepted. On the other hand, there may be other statements which will appear to contradict flatly those presented in other books. In both cases it would be wise for the reader to test out for himself the truth (or fallacy) of such assertions.

For instance, I have read recently that there is only one true blue, Ultramarine, whereas Prussian blue is condemned as crude and dull and of little use in landscape painting. Now it just happens that, except in rare cases, I have given up Ultramarine for many years, as I found it far too purple for the average sky blue, and even when heightened with Flake white, it tends to clash with nature's greens. On the other hand, Prussian blue is, for me, a lovely true colour and a sound basis for most summer skies, and with a touch of Alizarin crimson will give the right hint of purple, if required. It is absolutely permanent, and is indispensable for matching certain greens when mixed with your yellows.

If you favour a purplish blue, then I suggest Cobalt, as it is not so strong as Ultramarine, and with a touch of one of your reds will give you a number of cool greys.

Again, I have read that Emerald green is recommended as a colour that stands alone in brilliance. That may well be, but it is not a nature green, and even when mixed with Chrome yellow is a dangerously "pretty" colour for representing foliage or green fields in sunshine. I personally never use it, believing, rightly or wrongly, that Viridian is the only made-up green you need, and this, of course, only to be used in collaboration with one of your yellows. But in the end, the choice of these and other colours that come up for review must be determined by trial and error and by yourself.

And if I am in danger of over-emphasising the importance of self-determination, it is because so many beginner's and adult amateurs miss the joy of painting through the very fear of forgetting the written word, the authority for which should be tested out before being meekly accepted. Personal preference is born out of individual experiment and enterprise.

CHAPTER ONE

Tools of the Trade

FIRST, let us see what things you will want—the bare essentials, that is, because you can go on adding this and that as your painting develops, but to start with only the absolutely necessary tools need be purchased.

Paints, of course, head our list.

These should be students' colours, and get the large-size tubes. A small number of nice fat tubes is worth far, far more than a lot of little thin tubes—however attractive the colours on the outside may be. Here is a list of safe colours which, when you have learnt how to mix them, will give you all the varieties of tints and tones you could wish for.

8 oz. tube

Squeeze from bottom, and roll up tube

9

Flake white (1 lb. size because you'll find you use more of it than any other colour).

Then two yellows—Yellow Ochre, Chrome lemon.

Three reds—Alizarin crimson, Light red, Vermilion.

Two blues—Prussian, Cobalt.

Green—Viridian.

Brown—Vandyck.

Ivory black.

And if you want to make this up to a round dozen you can add Burnt Sienna—which is a hot brown, so be careful! These I repeat are all you want, as a start.

To these you can add, from time to time, Raw Sienna, Raw Umber, Ultramarine blue, and as a special treat Payne's grey or Cerulean blue.

Now for brushes.

Three or four at the outside are all you will want. Large, medium, small and a watercolour brush for small detail.

Next the palette. These can be obtained in two shapes, which I will call "studio", and "outdoor"—fancy or plain!

Studio palette

Plain palette

The first is graceful in design, but as you will see has less room for mixing your colours on, and I should always recommend the second, since you can use it indoors and it will fit into your paint-box when you go sketching out of doors. A box therefore is essential, and you can get a serviceable one at any artists' colour-man. The size should not be less than 16" × 12", and get one that

is not already filled with a lot of colours you do not want. Fill it yourself with your own selection.

 The paintbox will probably have a container for your turps and a dipper, this you fit on to the side of your palette and into which you put your turps. Ordinary turps from any ironmonger is all you want, and buy a good supply because you will need it for cleaning purposes as well as thinning out your colours when you are actually painting.

A palette-knife will complete our list. This should be trowel-shaped, because it is mainly used for scraping the surplus paint from your palette after operations and is more flexible for actual painting. I must not forget to add you will want plenty of old rags and newspaper torn into sizes convenient for squeezing out paint that remains in your brushes (between your finger and thumb) before rinsing them with your turps.

Before setting out our palette, let me give you some additional tips, however obvious they may appear. Squeeze your tubes from the bottom and roll them up as they empty. Always replace the cap on the tubes after use and see the cap is firmly on. Do not rinse your brushes in turps before you have semi-cleaned them with

Earthenware jar as brush-container

Bottle with screw-cap for turpentine

Glass jam-jar for rinsing brushes

newspaper, as the jar will soon get clogged with paint. Clean your brushes as *soon as you have finished painting*, it is so easy to leave them till the following morning—or even later—and then, well it is more labour and the brushes naturally suffer. The turps will be sufficient to keep the brushes soft, but I find that once a week it is a good plan to give them a thorough good wash with kitchen soap and water. They will last much longer with such care. Some artists like a film of dried paint on the palette-knife, but I prefer to keep the blade clean.

Now we are ready to put our colours out on our palette. And although there are other ways I think you will find that this order is logical, and once adopted you will find it automatic, because it is important to keep the same order.

Palette set out with colours in order

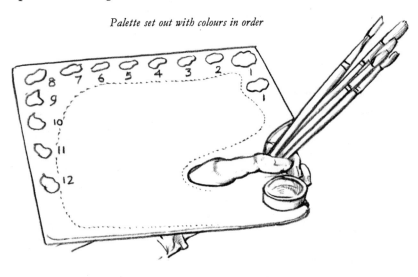

1	Flake white	7	Prussian blue
2	Chrome	8	Cobalt blue
3	Yellow Ochre	9	Viridian
4	Light red	10	Vandyck brown
5	Alizarin crimson	11	Ivory Black
6	Vermilion	12	Burnt Sienna

If the colours are squeezed out near to the edge of the palette, there is plenty of room for mixing, for it is this area within the

dotted line which must be kept scrupulously clean, and I mean that. It is fatal to let pools of colour dry hard on this valuable space, so that you have to scrape them off—such a waste of time! On the other hand the colours round your palette can remain, indeed if for some reason you cannot paint for some considerable time, and do not want to waste what remains, immerse the palette in water—the kitchen sink or some shallow receptacle—and the colours will remain moist for further use. You will see that by putting out the colours as suggested I have kept whites as far away as possible from my black, and the Prussian blue is in a corner of the palette, as far away as possible from one's sleeve, because it is a terrible colour for getting on everything and is the worst colour to clean off!

All you want now is something to paint on! Canvas? Yes certainly, it is one of the best, but there are other materials, and far less expensive. For our present needs, I suggest an oil paper which you can obtain from any art shop. It is sold in large sheets, which you can cut to the size required. It is especially serviceable for your first exercise, which is making a colour chart. Canvas boards can be used later, but these and stretched canvas are both expensive.

Folding sketching stool in the open and shut position
(aluminium with canvas seat)

CHAPTER TWO

A Colour Chart

FOR the absolute beginner I would strongly recommend the making of a colour chart. First squeeze out a small quantity of each colour on your palette, and with your brush paint a small square of each tint on a piece of paper or board. This will show you exactly what the actual colour is, as it comes out of the tube. Now mix white with each colour, making each tint lighter—viz. red will become pink, etc. You will notice the degree of difference in each mixture as the proportion of white is added.

You have now a series of *tones* of the same *hue*—the degrees are as many as you wish to make—until they are all *nearly white*.

Now take your two blues (Prussian and Cobalt) and your two yellows (Chrome and Yellow Ochre). First mix your Prussian blue with your Chrome yellow—strengthening the yellow with each mixture. Now do the same with your Cobalt blue and your Yellow Ochre. Two completely different ranges of green will result (see page 19). Next mix your Prussian blue with your Yellow Ochre, and your Cobalt blue with your Chrome yellow, and yet another scale of greens will result. It's quite exciting to see how many different kinds of green you can make without using the actual Viridian green.

Your chart as you can see, will be as extensive as you care to make it; because all these shades are dependent on the amount of one colour you add to the other. But in adding colours, take care to clean your brushes often enough—have plenty of rag and newspaper handy, torn into sizes convenient for squeezing out paint.

Now your three reds with your two blues—Cobalt with Alizarin or with light red or with Vermilion, and then your Prussian with the same three reds—you can follow this with your two yellows

and three reds—and finally you can add black to each colour on your palette and see how this "degrades" the original tint.

In my experience such a chart gives the beginner a real sense of colour—its degrees, tints and tones—and he will see with surprise and delight what a vast range there is to paint with; and all are obtained from your eight or nine original colours.

To the question "How do you mix a grey?" the answer is now, "What sort of a grey do you want?" Black and white will make a grey, but it's rather a dull grey, and you will discover that greys in nature have a bias towards some colour—like a greeny grey, a pinky grey and a bluey grey—and all these subtle tints you can now mix with confidence.

From this range of colours you can develop your natural or personal colour scheme, because to achieve colour harmony you must refrain from using too many different colours in one picture.

I have seen students use three blues (not shades of one colour) but three separate colours—Cobalt, Prussian and Cerulean—in one sky with distracting and discordant results. The fewer basic colours you use, the more harmonious your painting will be.

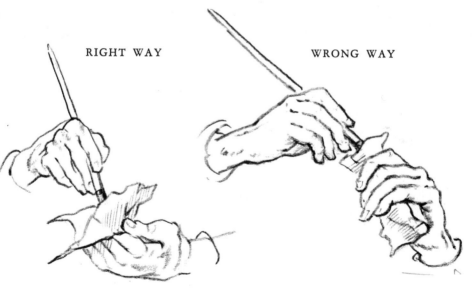

RIGHT WAY WRONG WAY

When squeezing out surplus paint from brush into newspaper, double paper round end of brush and squeeze between finger and thumb while withdrawing brush

From your chart you will see at a glance those colours which come under the heading of cool colours, which you will use for your skies and distances, and the other group which we call warm colours and which should be kept for our middle distance and the foreground of our picture. For just as cool colours tend to "go back", warm colours tend to "come forward", and I've seen so many failures from failing to observe this axiom i.e. paintings in which quite hot colours, reds and browns, appear in the distance while cold greens and blues are introduced in the foreground, that I cannot stress this point too much.

Up to now you have applied these various tints and tones with a brush in a small space. You may now safely try mixing certain of these colours, for practice, with a palette-knife, and applying them to your canvas or board with the knife. They will be thicker in texture and not so smooth—you will get slight ridges, uneven surfaces which are very exciting and invaluable for certain places in your future painting when you want to stress the solidity of some object.

Not that painting with the brush need be smooth—indeed I would encourage the beginner to paint thickly, so that he gets the joy—for it is a real enjoyment—in handling and mastering thick paint. The plastic nature of the medium is experienced from the very beginning.

You must become master of your colours and not a slave to them; indeed you must make them to do what *you* want and the best way to do that is to launch out with a fully-loaded brush and in the colloquial term—"have a bash"!

This is always a difficulty with beginners in oil techniques who have hitherto only painted in watercolours, which is a transparent medium, for while in watercolours you can be said to paint from light to dark, in oils it is the reverse—the high-lights are painted last, and painted thickly too!

More About Colours and Their Uses

ONCE you have thoroughly mastered your colours, one very important problem will have been solved. And this, like every other technical device, will only be surmounted by continual practice. I do not mean that you have to restrict yourself to colour mixing before you embark on a picture, but that the more you experiment, the more you try out different combinations of colours, heightening their brilliance, lowering their tone, warming and cooling them to your own wish and satisfaction, the easier you will find the actual matching of tint and tone when you are painting direct from nature. Soon you will be able to say to yourself, "Ah, yes, that's getting near it, it just wants a touch of this or that colour", rather than sigh, "Oh dear, how do I get that particular shade of green?"

But I must give a warning here. Sometimes colours in nature, especially local ones, if copied exactly may strike a discordant note in your colour scheme, and as producer you have the right to change the colour, to degrade it or brighten it, because it is your painting that will be judged on its own and not viewed alongside the original. I cannot over-emphasise this, having seen so many beginners' efforts ruined by an over-conscientious regard for truth to nature which only becomes a pictorial falsehood.

After all, the same freedom is enjoyed in the modification of your subject-matter when drawing in your composition. For instance, there are literally hundreds of different tints and shades in nature's greens, especially in trees, which if followed exactly would result in pictorial cacophany. On the other hand, there is a right and marked difference between, say, the conifer tree and the deciduous. The cedar, cypress, pine, fir, holly, ilex, etc., are all degrees cooler

and darker in tint than, say, the oak, ash, chestnut, lime, or beech, and, incidentally, the meadow, paddock, grass verge, in which they grow, is never the same green as the tree itself.

When painting evergreens, you can refer to your colour chart to remind you what is the better blue to mix with your yellows—Prussian or Ultramarine, or Cobalt—Yellow Ochre or Chrome. As a general rule, it is far better to sacrifice the brilliance of a particular green to something less bright but warmer in hue and which has more quality. Generally I find beginners' greens are all too cold, and that particular shade of apple green should be strongly resisted! For such reasons, never use Viridian by itself, but always mix it with your yellows, and with regard to the latter, never mix Cadmium yellow with a Chrome yellow—it may turn your colour black. I find Chrome ("lemon" and "deep") safer than Cadmiums, and unless you want to risk a pretty colour scheme, cut out all made-up greens and Cadmium orange.

COLOUR CHART, *showing the range that can achieved from the mixing of four primary col*

USSIAN BLUE YELLOW OCHRE COBALT BLUE LEMON CHROME

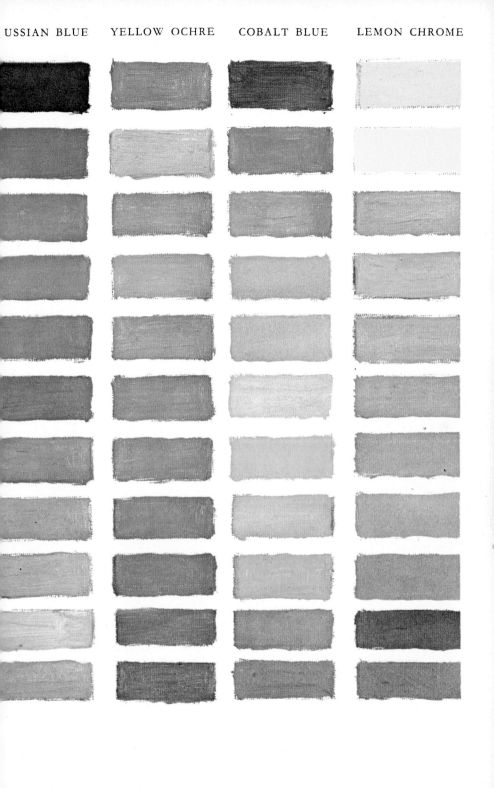

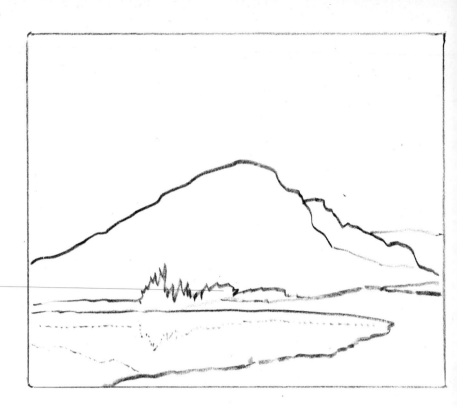

CHAPTER FOUR

A First Trial

FOR your first painting, I suggest a very simple subject. Simple shapes are all we want, as for instance this mountain scene. You could not have anything much easier to draw and there are plenty of big shapes to fill in with paint.

So why not start with a blue sky. Take up a quantity of white in your brush, moistening your colour with a dip of your brush into the turps first. Then start to add Prussian blue, but be careful not to put in too much blue all at once, because it is a very positive and

strong colour. We want it definitely bluer at the top of our paint-
ing than we do where it meets the silhouette of the mountain (so
as to achieve the dome of the sky). We should therefore add
touches of blue bit by bit until we have the right strength. By
gradually adding white to our blue as we descend, and by only
covering the area of canvas that our brush-load will encompass, we
will achieve the right gradation.

Having arrived at the mountain, you can use the same blue as
that of the sky, with one of your reds to make a bluish purple, and
by referring to your colour chart (for this is where it can come in
so useful), you can choose the particular shade you think best
suited for your purpose. Lay in the mountain shape with broad
flattish touches, and into this colour you can paint your shadows,
which are determined by where the light is coming from. If your
original shade of blue is on the dark side, you can save these portions
for the shadow forms and mix a lighter tint for the lighter side of
the mountain.

Now for the middle distance, which can be represented by a flat
tone of Prussian blue, with a touch of Yellow Ochre. If you intro-
duce trees, they will be seen in mass and again a mixture of Prussian
blue with a small quantity of Chrome or Yellow Ochre will give
you the right effect.

And here again you can refer to your chart to decide which
darkish green you think best. The distant bank can now be laid in
with a mixture of Yellow Ochre and a *touch* of Prussian blue, and
the edge of this bank can be drawn in with a loaded brush con-
taining a mixture of light red and Viridian green, as you will want
it to tell darker than the ground above.

We have now arrived at the water, which should be painted in
with broad horizontal strokes, the colour being a mixture of blue,
Viridian green and a touch of light red or Alizarin crimson (in
order to mute the local colour), and heightened if need be with
Flake white, especially where a ripple of light breaks the surface,
for this can, more than any other device, suggest the movement
and the "wetness" of water.

If you paint the reflection of the mountain in the water, follow
the shape (upside down and always vertically underneath it), and

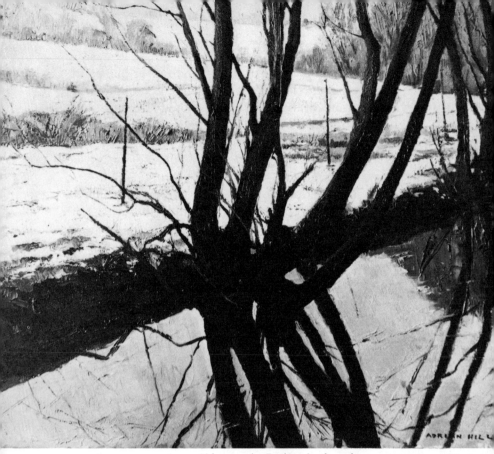

Alders on the Rother, *by the author*
An example of how reflections in water can make a good picture

this should be a slightly *darker* tone than that of the mountain itself. This applies to *all* reflections, whatever colour and shape they may be. This is most important, as I have seen so many examples of the exact opposite effect.

Now for the foreground bank. Here you can paint thickly and with warm colours—Yellow Ochre, Raw Sienna, light red—such colours fortifying your shades of green, which should be applied in broken colour, stabbed on, so as to give a texture of rough and very solid ground.

Of course I do not expect the reader to follow all these steps precisely as I have indicated them—indeed, I would rather that he does not, for it is never too early to try out a colour for yourself.

All I am concerned about is to present a possible method by which, as you will have seen, you can travel from the furthest distance, i.e. the sky, to the nearest point in the foreground, and incidentally from the top of your picture to the bottom. As a first exercise, this should give you confidence in handling and in mixing your paints, and you will have discovered how colourful your sketch can look and how few actual colours you have used.

You will certainly have learnt how to get your colour from the palette to your brush, and from your brush to your canvas or board. Painting *across* the form of the mountain—and *vertical touches* will best represent distant trees, longish *horizontal sweeps* for water, and *short stabbing touches* with a loaded brush for the immediate foreground. And finally you will be free to add whatever detail you feel the particular subject needs, a cloud or clouds in the sky, for instance, but this I will deal with in the next chapter.

Skies in Landscape

IN landscape painting, if you choose a low horizon subject, it at once implies that you consider the sky, or what is happening in the sky, to be of major pictorial importance to your picture.

In other words the subject would not be worth recording if it was seen under a cloudless sky. For it is obvious that all subjects in nature are composed of sky above and the earth beneath, and they can be roughly divided into high or low horizon compositions.

If your painting has a high horizon line, it is obvious that this portion will be far less in area than that below the eye and can be said to be of supporting interest only. To fill such a restricted space with a busy cloud formation would be distracting to the viewer and rob the painting of its proper focal interest, which should occur somewhere in the landscape underneath.

On the other hand a sky effect is often the making of a picture and thus the study of clouds becomes an essential part of all land-scape painting, especially as a picture can be made or marred by what is happening above the horizon line. For that reason I am stressing the importance of what can be called aerial composition.

In the following diagrams I hope the reader will agree which is right and which is wrong! I know they are very obvious examples when once seen, but I know how easy it is to slip up on such occasions.

In colour, the first rule to be remembered is that in a clear blue sky devoid of any clouds, the colour is more positive blue at the top of our picture—that portion which we have to raise our eyes to see in nature—than it is when viewed directly above the horizon. If, as I suggested in a previous chapter, we break down our blue with a gradual increase of white we shall achieve this lightening

WRONG RIGHT

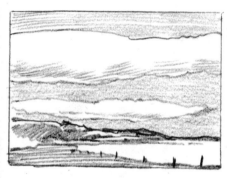 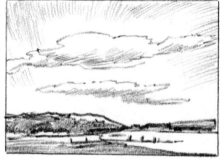

WRONG RIGHT

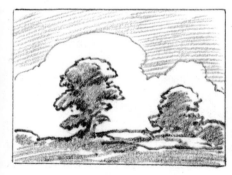 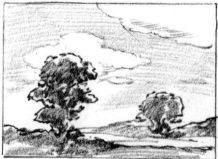

WRONG RIGHT

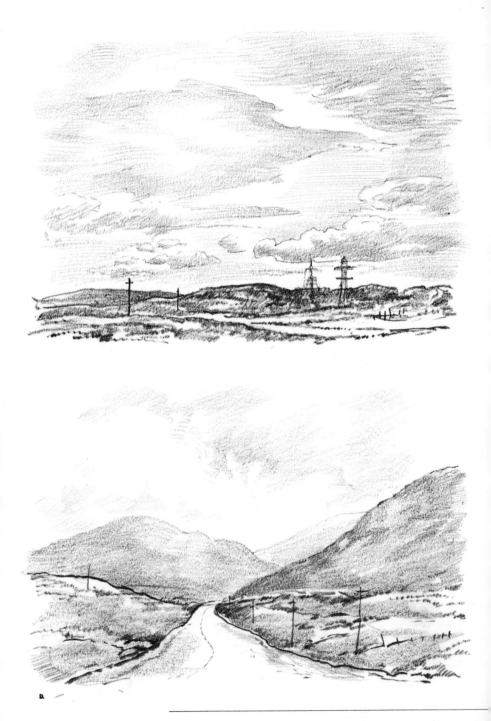

Four low horizon subjects which depend on the pictorial interest of a sky e,

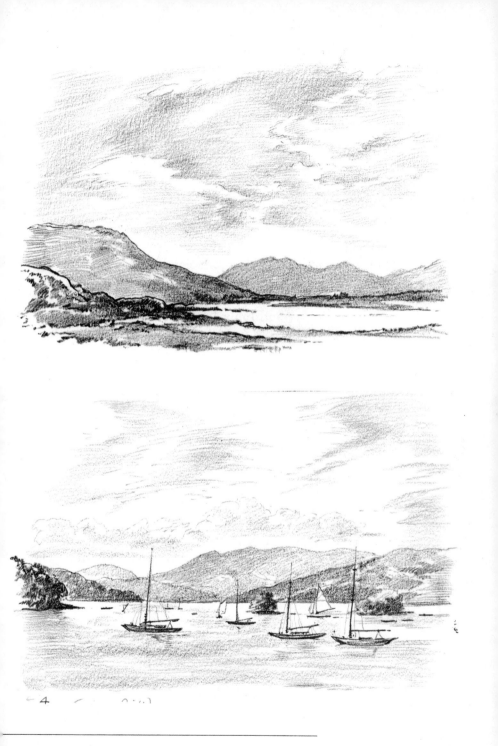

supplement the landscapes, which need a support but not a rival in interest

effect which will convey the dome-like nature of the sky. This I recommend as a first exercise. Without this gradation the sky will resemble a blue backcloth. Once we have mastered this principle of colour perspective we can introduce clouds of all kinds, cumulus —those majestic cauliflower shapes—cirrus, elliptical or scaly clouds, "puff balls", ragged storm clouds, in short, the whole heavenly wardrobe, with which nature "dresses" the sky.

Of course our sky colour will not always be blue and it is not necessary to cover the whole area with any one sky tint, especially if there are a number of clouds forming a distinct design. But we must remember that where the sky *is* revealed, it becomes lighter in tint as it approaches the horizon. Isolated white clouds will soon be noticed to have a clearer (not sharper) definition at the top than underneath. Their lightest portion is also at the top, while at the bottom they are softer and more indistinct in outline. Obedience to this rule will ensure that your cloud has depth. Cerulean blue and Vermilion with white (of course) will produce that subtle tint for the shading of your white cloud.

As I have already warned the reader, for me Ultramarine should not be used to match the blue of an English sky. It is far too purple a blue however much Flake white is added, and such a royal tint clashes badly with all nature's greens. Whereas Prussian blue, as I have said, is a lovely natural sky blue—absolutely permanent and far nearer the actual colour of a summer sky. But try both and see which you prefer.

One tip I think all painters would agree on, never use Chrome yellow for those warm passages that occur in clouds—it is far too near green to be safe, and can all too easily mix with your blue and produce a horrid greenish stain. Yellow Ochre is the safest yellow —with plenty of white; and the merest *touch* of light red—Vermilion, will match those fleshy portions of white clouds. Pure white is too cold.

TOP *Take away the evening cloud formation from subject and the landscape is dull and devoid of interest*

BOTTOM *A lively handling to convey movement both cloud and tree forms*

There is generally a good deal of grey in English skies, pink greys, yellow greys—your colour chart will help you to mix the right colours in the right proportion to get the right shade.

I would warn the student that sunsets in which the actual sun is shown should be avoided. Turner did it once in his famous picture of *The Fighting Téméraire* in the National Gallery, and he certainly brought it off (despite the fact that the sun is sinking in the East!). For the beginner, however, I think it is wiser to leave nature to paint this effect, and wait until the crimson orb has sunk out of sight and only the afterglow remains!

In any case there is an unlimited range of sky effects that can be attempted without pursuing the sensational or too dramatic moods of nature.

It is only when painting skies that we realize how quickly cloud formations change their contours and design; clouds which appear to be static are continually on the move. In this respect the landscape painter has truly been said to be "chasing nature", and such effects can only be painted with *urgency*. It is in my experience the only method to capture their transitory appeal. A glance at the colour illustrations will I hope denote the various techniques employed for skies to harmonize with different kinds of landscape.

Still Life

AS a course of study, painting an inanimate group of objects is often neglected because it is voted a bore. It needn't be.

Still life painting offers the student plenty of time to come to grips with the problem of matching tint and tone with greater accuracy than that afforded in any other branch of painting. In front of the bodily image which is static and which in a steady light remains the same in colour and tone, the beginner is free to concentrate at leisure and continually refer his painting to the original. Such an exercise teaches accurate chromatic vision and a proper regard for tonal values. For the group to be painted, I suggest a simple arrangement—two or three bottles of varying sizes, shapes and colour, against a background of some definite contrasting tint. Too many assorted articles will only confuse the issue.

Composition, I need hardly add, as in all picture-making, plays an important part. For it does not matter how few the objects, they must be arranged in some pictorial order. A glance at the diagrams on page 34 will, I hope, prove my point. By moving the objects about, a suitable composition will be arrived at, and only by so doing will the number of possible variations be disclosed. Second or third thoughts are often proved to be better than the first.

And although this process of rearrangement may take time, it is never wasted, for once it is settled upon and checked up, the actual painting can be tackled with a greater sense of freedom and confidence.

In my six diagrams it will be noticed that while the groupings are all different, the jug and glass retain their positions on the *right* of the bottle, which suggests how many other variations are possible if the objects are re-formed so that the bottle is seen on the

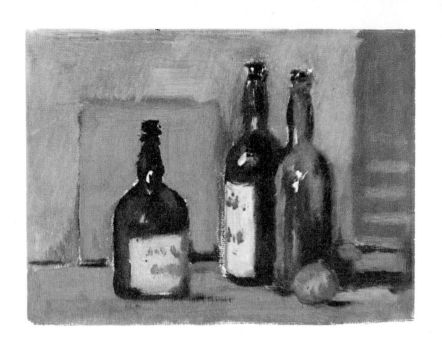

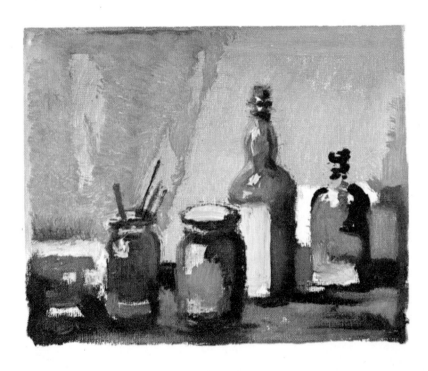

right and the jug and glass take up new positions on the left hand side. Composition, believe me, is all that important.

In my two examples of simple still life paintings (opposite), a word or two about procedure may help. The group is first drawn with charcoal, and the outlines brushed in with some such colour as light red, or Raw Umber. Now the background and the objects themselves can be stained with colour, approximating to the local tint but not necessarily the exact colour, the desire being at this stage to cover your canvas or board all over so that the broad masses are established and you can see better what your picture is going to look like.

Then with far less turps and far more pigment you can begin to paint the background at full strength. It does not matter if you go over the outlines of your bottles—in fact, it is better that you should, because you will then be obliged to paint *back* into your background to recapture the outlines and thus obviate a hard edge. It is impossible to detail the subsequent stages of your painting, as everybody must be free to follow their own personal inclination. But I would add that it is advisable to paint from *dark* to *light*, i.e. your half-tones should be painted over your darks, and your high-lights superimposed on these areas. In the case of the high-lights on the bottles use a fine brush well loaded with white. This accent must be laid on with a deft touch and left, for it is these final crisp accents in the right place which will give the *form* as well as the glassy texture of the surface.

Never paint round your high-lights, but boldly *on top* of the half-tone.

In my second example, you will notice that I have had more "fun" (in the best sense of that overworked word) in the actual painting, "chancing my arm", if you like, in order to achieve a more lively painting, and being a slave neither to exact local colour nor to niceties of form. Such personal freedom may be considered the

TOP *The painter as "announcer"*

BOTTOM *The painter as "producer"*

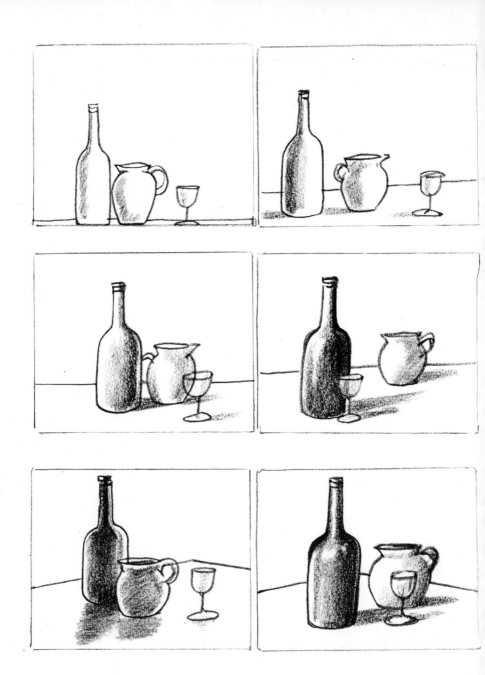

Variations on a theme

natural reward for the self-discipline imposed by the rules govern-
ing the previous study, but I would add that freedom of execution
can only be fully enjoyed when the spade-work has been done.

In both cases keep comparing, through half-closed eyes, your
painting with the original, in order to retain balance and harmony.
When flower paintings are attempted, it is imperative that your
background colour should be well established first, so that the
flower forms are boldly painted over with a full and flowering
gesture of the brush. Only by this means will you achieve life in
the flower and depth in the background—projection and recession,
the moving against the static.

Choosing Your Viewpoint

S O many beginners make the mistake of being in too much of a hurry and painting the first view of their chosen subject that I shall devote this chapter to sorting out this problem.

For this purpose I propose to take a typical village church (Ashbury in Berkshire), and demonstrate by the following "roughs" the number of variations on the same theme that may be obtained by walking round your subject—boxing the compass if you like—in order that you will in the end, discover the best viewpoint from which to paint your finished picture. It may well be that you find by this method more than one aspect which makes a good composition and you will certainly have collected a lot of useful reference for possible future pictures.

You will see that I made six roughs in all and spent a leisurely morning in strolling round and making my little sketches. In what better way could I have employed my time? For truly I became far better acquainted with the architectural features of the church than if I had made only one study of the building. Drawing something only once is merely nibbling round the crust.

Look at No. 1. This was my first view, looking up the street—an obvious upright composition, but I was not very happy about the way it worked out. The cottage on the right was pushing its way in too far and consequently the church appeared cramped, even elbowed out of the picture.

In No. 2 I retraced my steps and mounted the grass verge on the right. But now the line of young lime trees, which I felt were necessary to give depth to my composition, appears to be pushing the church out of the picture on the right! Also the design was too complicated.

(1)

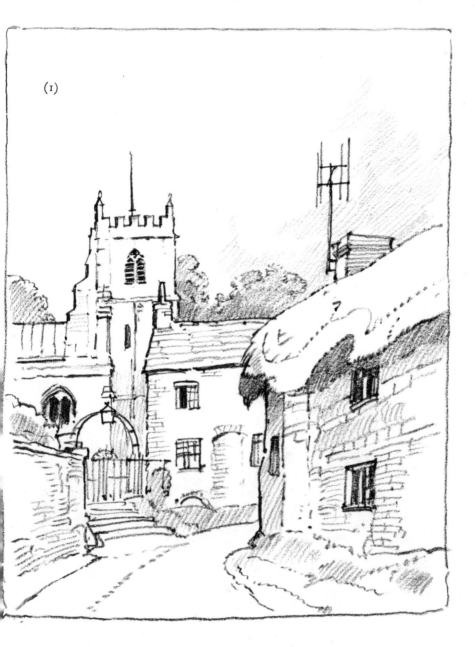

This was the first viewpoint I chose, I had to do five more sketches from varying angles before I got the composition I was really satisfied with. I then made the finished painting which is reproduced on page 42

No. 3. I tried a drawing of the church by itself, taking up my position behind the wall of the vicarage garden. I liked the solid mass of the church and the light and shade would have made for an effective painting.

No. 4. In this drawing, I took up a new position well to the left of the church—foreshortening the nave which now obscured all but the top of the tower. Also I was able to introduce a strip of foreground. Again the shadows made happy shapes and the general composition was compact in its masses.

No. 5. I had now walked round to the back of the church. I did not spend any more time than it took to make an outline drawing from this new position as I soon realized that I would never paint the subject from this uninteresting viewpoint.

No. 6, my last study, is seen from a completely new angle. The church tower dominated the scene. I now felt confident that I had found what I felt to be the best composition and so my sketch was completed in light and shade.

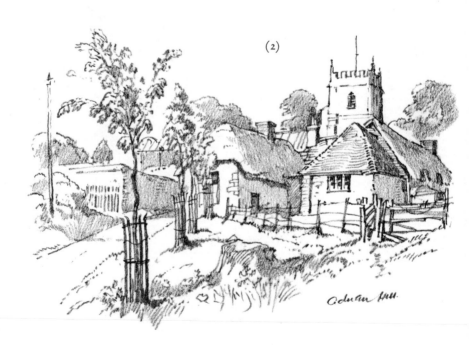

(2)

Colman Hall.

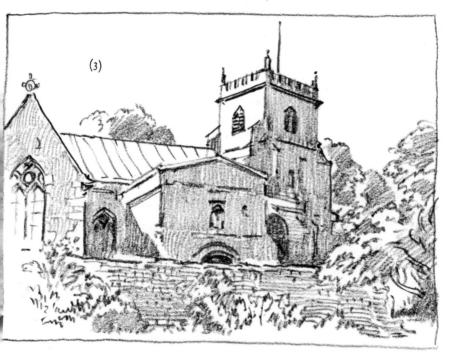

(3)

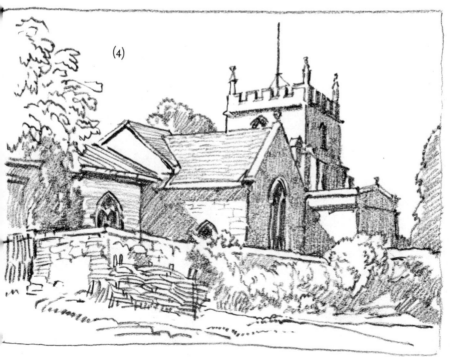

(4)

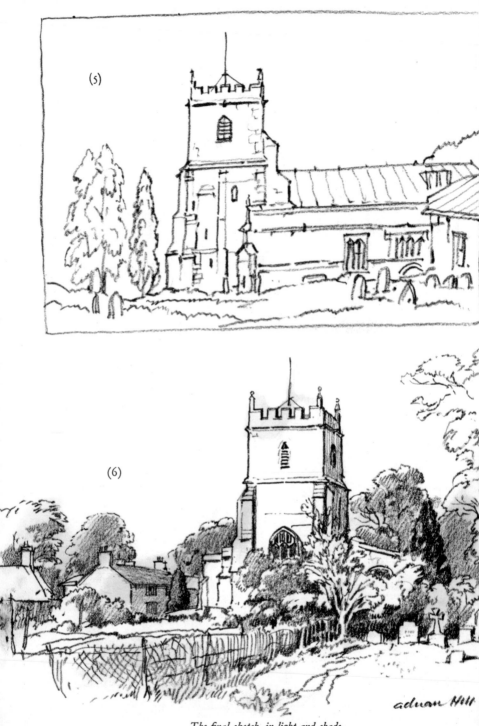

(5)

(6)

The final sketch, in light and shade

adrian Hill

From Rough to Finish

HAVING chosen from your various "roughs" the best in your opinion for an oil painting, it is important to select a board or canvas of the *same dimensions* as your sketch. A size which is squarer or longer will present an unexpected problem of having to readjust the lines of your composition. In the two illustrations in colour on the next page I have given two stages in the actual painting of the church and surroundings at Ashbury from the last of the "try-outs" discussed in the previous chapter.

The subject-matter in the top illustration has been redrawn in charcoal on a canvas board. Having checked up with the rough so that the masses and shapes left between the various forms correspond closely with the original sketch, the charcoal lines were then painted over thinly with an earth colour, in this case Burnt Umber, as I had some over from a previous painting. I used plenty of turps with which I continued to stain (rather than paint) the rest of the subject. The colours I used were: for the sky, Prussian blue, Yellow Ochre for the church tower, Burnt Umber for the shadows and trees; and the ground area I brushed in—stained is still a more descriptive word—with a thin mixture of Raw Sienna and Prussian blue. The idea behind this method is to cover the white surface of your canvas as well as to establish an approximation of the tone values, a range of warm tints into which you can paint all the local colour later. No attempt at detail should be made and no Flake white is used, all the colours being thinned out to the required tone by turps.

And now for the actual painting. Whether you are painting direct from nature or working from colour notes made on the spot, I would strongly advise a limited number of colours, making up your

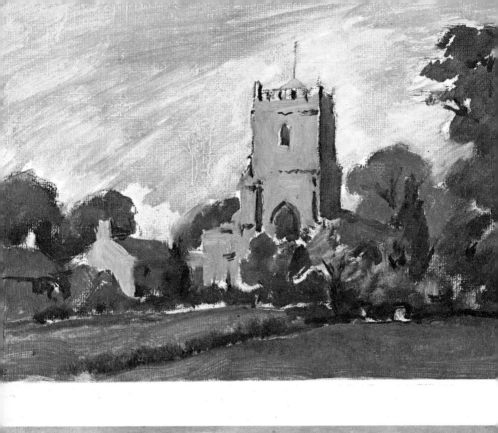

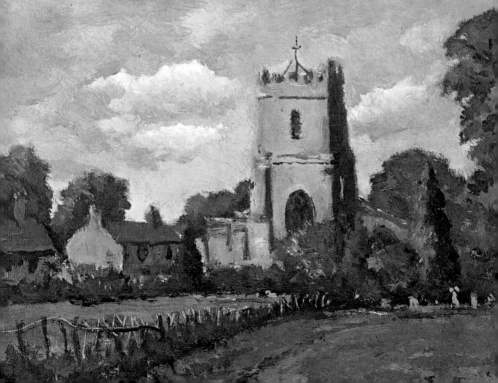

mind that within this range you will try and nearly match the various tints by judicious mixing. For even if you do not achieve some particular shade exactly, by restricting your colour scheme your painting will have an all-over harmony which is far more important pictorially when viewed, as it will be, away from the subject.

My palette in this instance was limited to Flake white, Yellow

RIGHT

Position of hand on brush

WRONG

Ochre, Raw Sienna, light red, Lemon Chrome, Burnt Umber and Prussian blue.

For the beginner, limit your number of brushes to three or four, and always use larger ones than you think you can manage! Small brushes, except for essential small detail, are death to broad, confident brush technique.

Take plenty of colour for your mixtures and before applying the paint to the canvas, see that you have collected the paint on the end of your brush. Keep your fingers as far up the handle of the brush

POSITE
ʰbury Church. *Final composition in colour*
ₚ: *First stage* BOTTOM: *Final stage*

as you can and resist the temptation to "smell your painting"! Having laid on a tint, don't keep stroking it backwards and forwards (a very common failing) but leave it and extend the operation with a freshly loaded brush, overlapping the preceding touch. It happens—always happens, I would say—that after the painting has been in progress some time, all the available space on your palette will be occupied by colour mixings and all your brushes will have been used.

At this stage some light colour may be desired, some fresh tint desperately wanted to brighten the effect. So often the beginner dives with a soiled brush into the white or yellow, which is already slightly discoloured or muted by a previous mixing, and although more fresh colour is squeezed out it will be introduced into the remains of the previous pigment, and worse still as a used brush is pushed into this discoloured mixture, the hope of lighting some leaden portion of your picture will be doomed to failure. It is on these occasions that a general clean up is absolutely necessary. Remove all the colour mixings from the inside of your palette with your knife—you can, if you wish, mix this residue and add it to your colours round the outside of your palette, but I find the result is generally a greyish green and rather a muddy tint at that. Rinse through your brushes with turps, and having squeezed out fresh paint you will be fresher yourself and will return to the attack with renewed confidence, supported by clean colour and brushes.

In the lower illustration you will see how I have tried to overcome the various problems that arise when completing a picture away from the subject. The sky portion remained a "rub in" (as seen in the upper illustration) until the rest of the painting had developed sufficiently for a certain sky effect to suggest itself. Painting direct from nature, I would have completed the sky first, as the mood of the day would decide the tints and tones of nature's forms underneath, which of necessity must be influenced by what is happening in the sky above.

As I had made my sketches on a fine morning in June, I tried to recall the fresh breezy effect which prevailed at the time. The result is overworked, but carried through purposely as a demonstration to encourage the beginner to work out his own salvation by

resisting the temptation to achieve a smart, slick effect. It is far better to eliminate, soften or broaden some portion of your picture than try and introduce pictorial interest into an empty space! The lesson of simplification will be more properly appreciated by this method. Of course this should be done while the painting is still wet, whereas precise accents can only be added with effect when the underpainting is dry, for obvious reasons.

With regard to the time spent on one particular painting, it depends of course on the degree of speed that comes natural to each student, the degree of finish which is desired, and the degree of progress you make with your painting. As freshness of execution is such an important attribute to the beholder's enjoyment of any oil painting, I would say that not more than two sittings, plus finishing touches, are necessary for any picture up to the size of a $24'' \times 20''$, as any time spent after that is generally in attempting some major restoration or retrieval, the success of which is highly improbable. Better far to scrape it off and start again!

Arranging the Composition

COMPOSITION plays such an important part in the painting of a successful picture in oils that it has been placed by many artists above both drawing and colour. And I think this is true, because although the drawing may be impeccable and the colour of the highest quality, if the composition is at fault, it will fail to satisfy the eye.

Beginners mistake

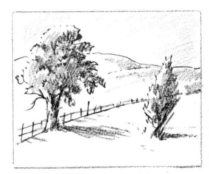

Improved composition

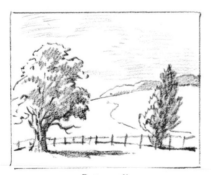

Better still

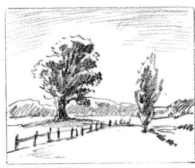

Another improvement

What you see *As it should be seen*

What you see *How you should see it*

Now there are a few hard and fast rules which govern a good composition, which are so well known and so obvious when pointed out, but are so frequently forgotten by the impulsive student who is over anxious to get on with the actual painting. And they can be all boiled down to the axiom that the painter must lead the eye of the beholder *into* the picture and not *across* it.

Into the picture, may I repeat, does not mean into the centre of the picture, but towards the centre, to some focal point where the eye can rest and be content to remain. In the following number of diagrams I have tried to illustrate how this principle works, and what happens when such directives as are necessary to guide the eye are not sufficiently emphasized, or are omitted altogether. And for the complete beginner, I have started by showing the elliptical area inside the picture frame where the interest should be focused, and outside which arresting forms or detail should be excluded.

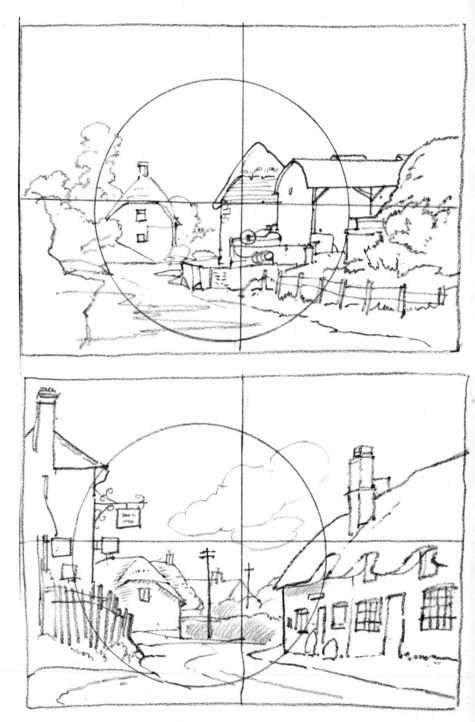

Where the eye should come to rest

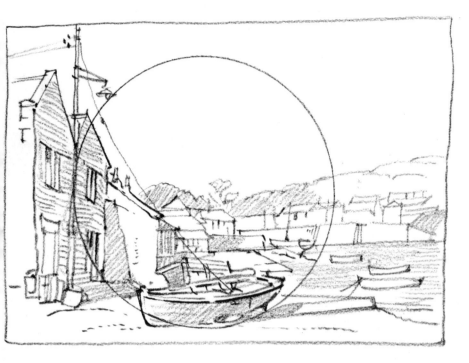

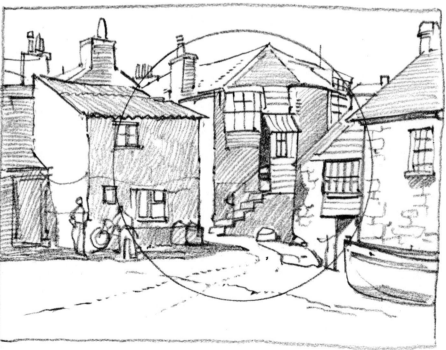

Focal interest within circle

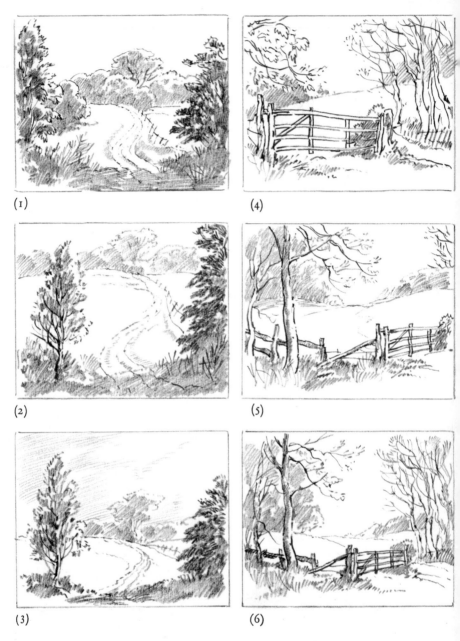

(1)

(4)

(2)

(5)

(3)

(6)

In *1, 2,* and *3,* the lighting is the same, but in
2 and *3* the horizon has been raised and lowered
giving an entirely new slant to the subject

In *4* the gate is the principal character with the
trees as supporting interest only
In *5* the tree and gate are rivals in interest
In *6* the gate acts as a link between the tree
forms, and balance is restored

Two examples where strong cast shadows can make a good composition The buildings on the right become solid, and the silhouette of cars on the left, with their shadows, direct the eye across the road where the figure arrests the eye and leads it up the street

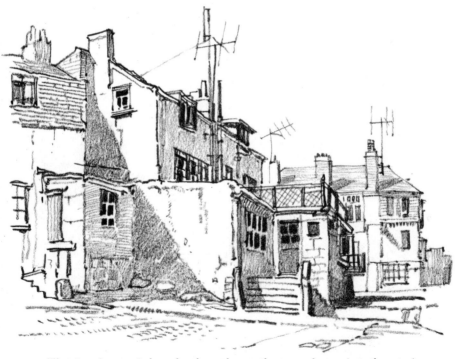

The triangular cast shadow takes the eye down to the steps and up again to the central house and down along the roof and dormer-window to the balcony in front

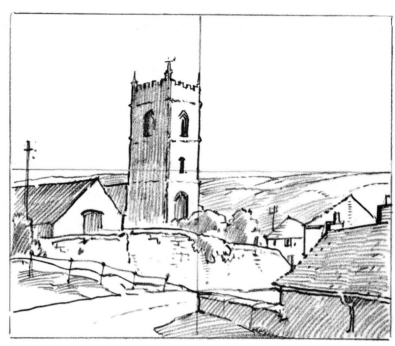

Silhouette of building in foreground unbalances the composition

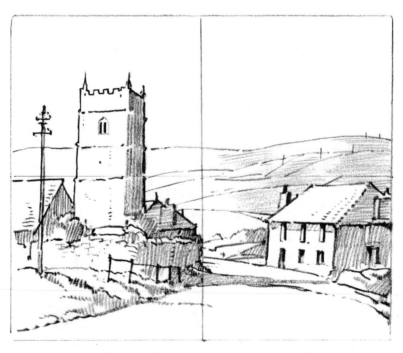

No central focal point

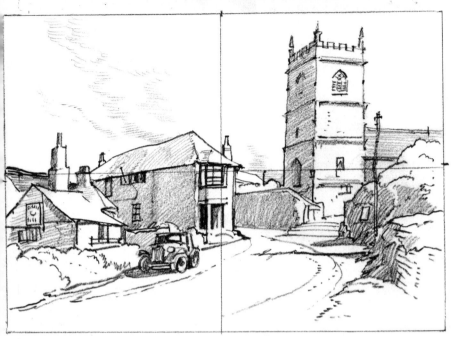

The introduction of a tree behind the cottage on the left would help to balance the church tower

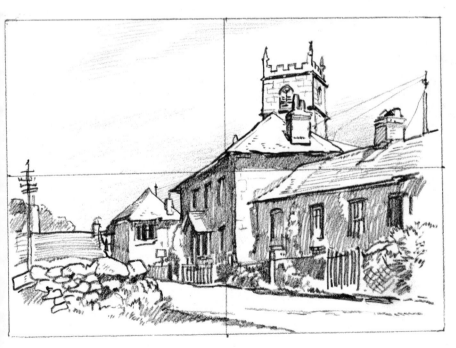

Here the church tower relegated to a background support

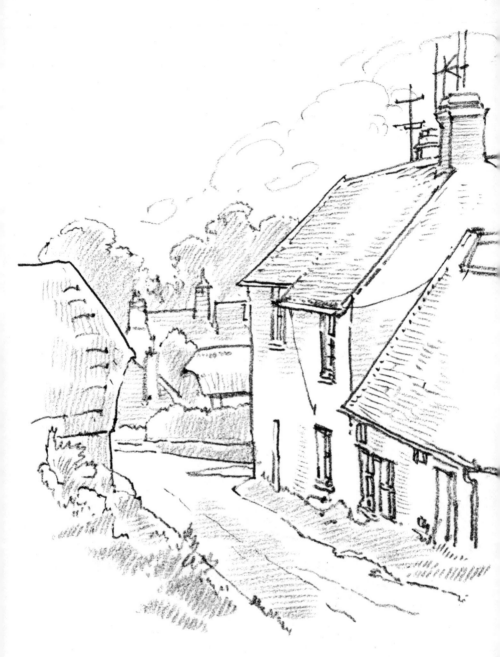

Drawn without proper regard for light and shade

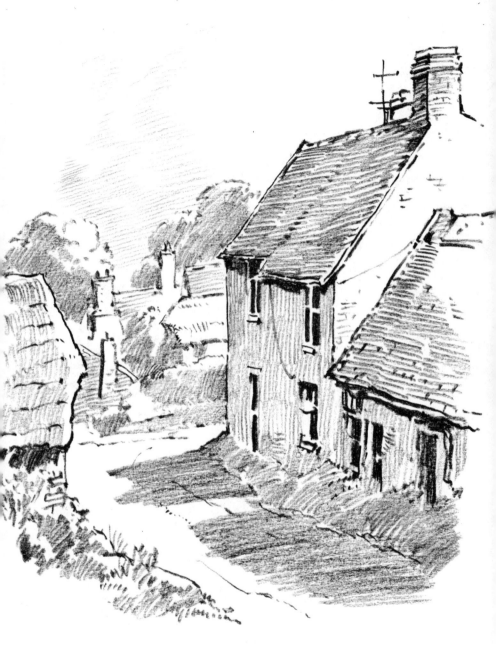

Light and shade duly noted

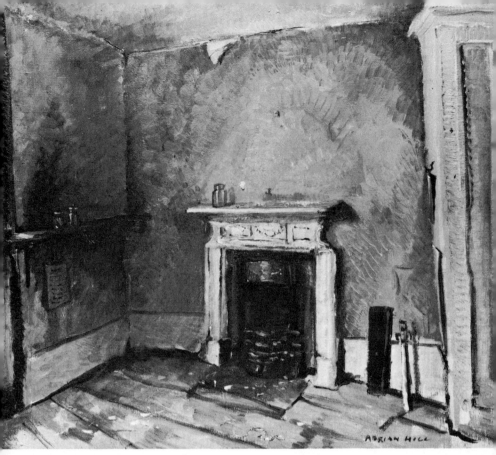

With Vacant Possession, *by the author* (Private Collection)

CHAPTER TEN

Interiors

THERE is great scope for the beginner in interior subjects, especially during those seasons of the year when outdoor sketching is prohibited by inclement weather.

In one way "interiors" resemble "blown up" still life compositions as all the forms are still properties and they are all seen within four walls, and are lit from outside by one or two windows.

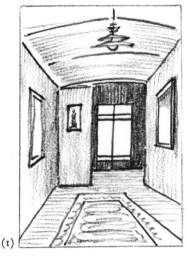

(1)

Laws of perspective are here essential to convey recession

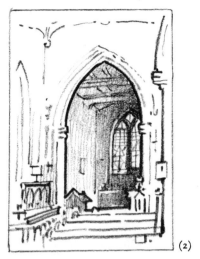

(2)

Focal interest must be concentrated within the central arch.

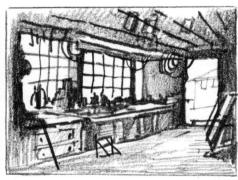

(3)

Visual movement down to the door is slowed down by pictorial detail on the left

(4)

Some suggestion of a view beyond the window is of pictorial necessity in this interior

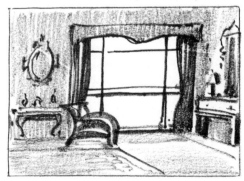

Our setting is box-like in design and so some knowledge of perspective is required. One important rule must be restated, for without it our room will lack a sense of depth.

It is well known that parallel lines on the ground-level if extended out to the horizon appear to converge and finally meet at what is known as the vanishing point. It should here be further recognized that parallel lines on the vertical plane appear to do the same thing, i.e. converge and ultimately meet.

So if two flanking walls appear in our picture, in each case the line of the ceiling and that of the floor, being parallel to each other will also converge and meet at the vanishing point on the horizon line. And if we remember that the horizon line (on which our vanishing point must occur) is *always on the level with our eyes* we will notice that the lines of the ceiling which is *above* our eyes appear to *go down*, and those of the floor which is *below* our eyes, appear to go *up*.

Once that is properly understood (and you can prove it for yourself, as you sit or stand in your room) then our picture will achieve depth.

In nearly all interior subjects one or two walls will appear. I have shown in the preceding diagrams how these principles of perspective apply.

In painting an interior subject in which a window is shown, whatever the local tint of the surrounding wall may be—it may even be white—it must not be lighter than the sky seen through the window. You can try this test for yourself. If you have a casement-window, of which the framework is white, you will see more clearly (if paradoxically) how dark a tone it is if you look at it in comparison with the light of Nature, *through half-closed eyes*. That is the surest test and notably where all light colours are concerned. And it will surprise you to see how deep a tone they become wherever they approach the borders of a window.

In oil painting, whatever subject is chosen, and especially in an interior, keep the portrayal of detail, especially high-lights, until the very end. See your subject in simple broad masses. A painting closes up, as we say, all too quickly and concern for detail will only result in a catalogue of isolated objects. In a word—and I know it is not easy—try and retain your first impression of the subject all the

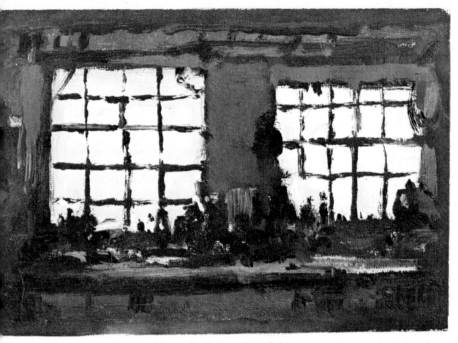

Example of strong direct lighting

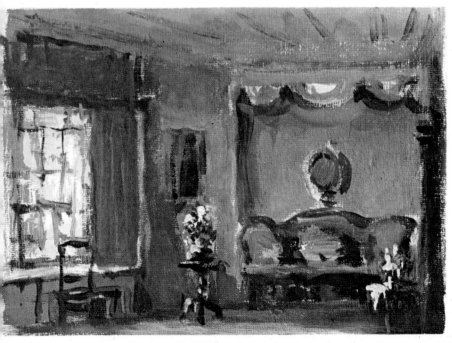

Example of subdued indirect lighting

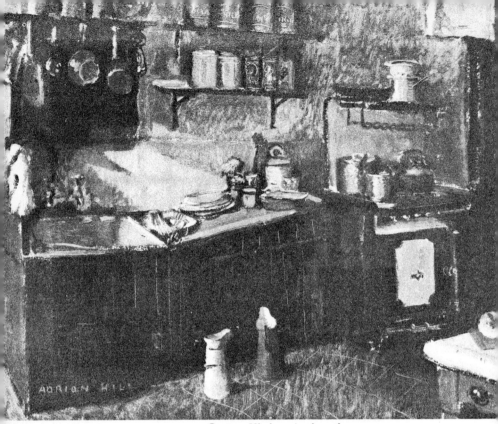

Cottage Kitchen, *by the author*

while you are painting it and—harder still—paint the *"particular"* so that it becomes integrated with the general all-over picture.

Local colour may sometimes appear in the original which if copied exactly may prove a discordant note in the colour scheme of your picture. If so, it must be lowered in tone or even another colour substituted.

In interiors where the subject-matter is close up and detailed (bric-à-brac of various sizes, colours and design), by half closing your eyes you will distinguish the important from the not so important; indeed half the charm of many interiors is what is lost and found, where mystery enhances the scene. Suggestions, therefore, if deftly indicated, will be filled in by the beholder. Finally, do not cross all the T's and dot all the I's, but give the viewer something to do. He will enjoy "reading in" what you have purposely hinted at.

Heads

T HE painting of portraits is a very highly specialized branch of Art and requires very special training. Nevertheless the lure is very strong and many beginners soon confess to a positive longing to paint heads, or faces, but they rarely appreciate the difficulties until they are overwhelmed by them. Only then do they ruefully admit that it is far harder than they imagined, especially if they are not very strong on drawing! And you can never get away with a painted head if the drawing is weak. So my first tip would be a warning: do not attempt to paint a portrait until you have

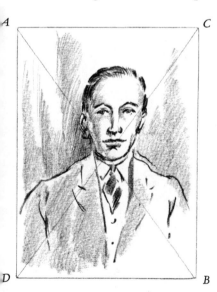

Full face, chin resting on or near where lines A, B, C, D, intersect; medium light from the right; draped background

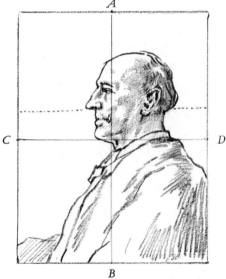

Profile, note position of head in relationship to the lines A, B, C, D

drawn more than one—and preferably draw your own head, full face in a looking-glass. See that you have a window to light your head, either from the right or left so that you get help from strong shadow forms and when you have finished, draw it again—and again!

Do not strive after a likeness, but concentrate on making your head *solid* and well constructed—eyes that can open and shut, a forehead which discloses the bone formation of the skull, a nose which has sides to it and appears to project beyond the lips—and see too that the mouth can open and that being set in the head will follow the curve of the face and not appear to float in front of it. Draw with a soft pencil, three-quarter life size—and I promise you you will learn a lot.

Only practice will familiarize you with the fundamental principles on which all heads are constructed, and there are books dealing specifically with portrait painting to which you can refer.

Canvas paper or board is adequate for your early attempts at painting a head. First draw it in with charcoal and see that you

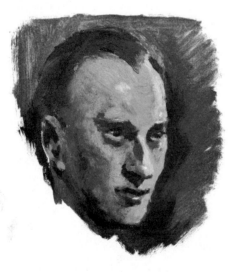 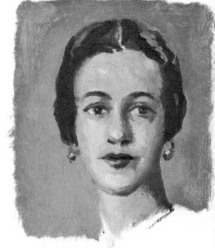

Dramatic lighting here reveals the distinctive characteristics of the sitter's features and personality

To preserve the youthful nature of the sitter, a moderate lighting (from the left) has been used. This will prevent over-modelling

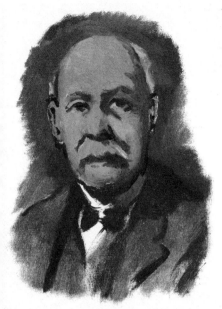

FIRST STATE	LAST STATE
Having fixed the proportions, the all-over flesh tint has been rubbed in as a basis for the lights to be painted in later. The same procedure for the shadows, under eyebrows and nostrils and moustache, so as to establish the broad masses of the head. Background tone has been brushed in round the head—also coat	*Leaving the high-lights on forehead, nose and pupils of eyes until last. The features have been modelled as far as possible together. Local colour on cheeks, and eyebrows, hair and moustache are added while underpainting is wet. Final touches to strengthen or soften the modelling where required are now added with precision and not overworked*

Palette used: Flake white; Yellow Ochre; light red; Terra Verte; Alizarin crimson;
Cobalt blue; Ivory black

have the main proportions right—especially the length of nose (which beginners generally make far too long). Check the distance of forehead, distance of eyes from wing of the nostrils, width of mouth, length of chin. These are the essentials, and when reasonably correct go over these lines with your brush and a thin wash of light red. Having established the lines of construction I recommend you rub in the background colour with turps—then the tone of hair and shadow forms on forehead, sockets of eyes, band of tone round the cheek-bone and side of nose. This tint can be a mixture of light red and Viridian green or Terra Verte. Your palette for heads should be limited and I suggest the following colours:

63

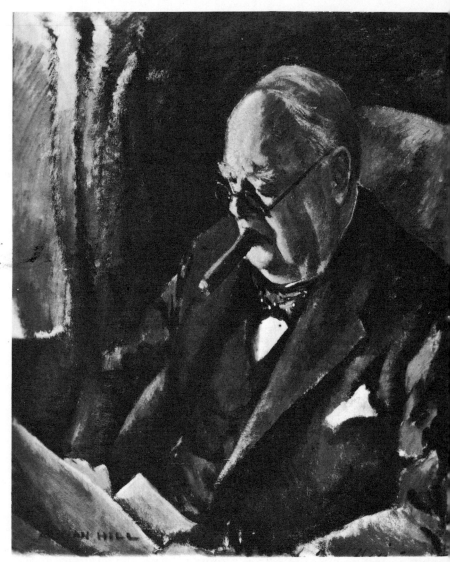

The Right Hon. Sir Winston Churchill during his wartime Premiership, painted by the author

light red, Yellow Ochre, Viridian, black, and of course Flake white. Local colour for eyes, lips, hair, etc., as conditioned by the complexion and colouring of the sitter. Next lay in the general colour of the flesh, so that the face is covered and simply stated

in its broad planes. The shoulders, and if dressed the collar and coat or blouse, should be rubbed in.

No white canvas should now be showing. You can now proceed with modelling the features—painting the eyes into the tone of the eye-sockets. Keep referring to the facial accents and comparing the strength of the tones through half-closed eyes. By this well-tried method you will see where the real darks, half-tones and high-lights occur. Finally, remember that the high-lights should be painted in last. Until then the head must be kept going all over—and do not forget the ears, their right position with regard to corner of eye and wing of nostril, and their local colour.

But as I have suggested, only by familiarizing yourself with your own features will you be competent to tackle all the problems involved in painting a portrait of someone else.

Beginners, fired with the hope of a quick success, seek the help offered by a photograph. This is natural. The spade-work has been done for them—there is the face, immovable, already translated into two dimensions, with more often than not a pleasant two-way lighting. It looks all too easy and only needs a correct and careful eye to follow the areas of light and shade to obtain a fairly faithful copy. The colouring is, for obvious reasons, a matter of flesh tints for those areas not in shadow. And as the shadows in the photograph are strictly in terms of tone, monochromatic tone, these are painted in greys and blacks with the result of a tinted photograph and nothing more.

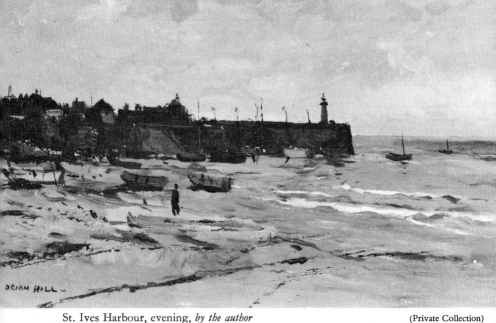

St. Ives Harbour, evening, *by the author* (Private Collection)

CHAPTER TWELVE

Outdoor Subjects

BOTH mountain and coastal scenes make excellent subjects for the beginner in oil painting, as mountains (or hills) present large solid shapes, and rocks, cliffs, and water offer broad areas which can only be tackled successfully with large brushes and thick paint. The following illustrations are typical, I hope, of simple and varied compositions which lend themselves to bold handling. Detailed objects are for the most part absent, and there is no delicate drawing to impede the sweep of the brush, and what detail I have included for pictorial interest can be safely left to the last stages of the painting. The barest outline only is necessary before starting to paint. But that outline must be correct, for I hope it will be noticed that some of the compositions are better than others, and I have shown, as I did in an earlier chapter, the changes which can be rung on the same subject by heightening or lowering the horizon line.

66

Viewfinder to decide best composition of a wide-angled subject

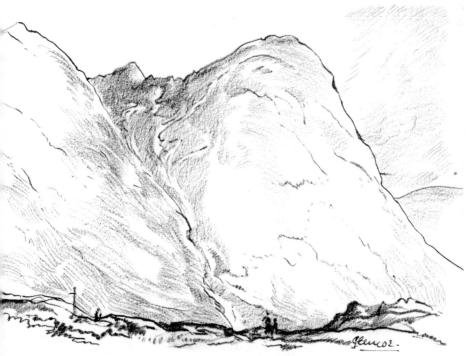

Here the eye is directed up the mountain by the water-worn ravine, and height is achieved by the inclusion of the two little figures

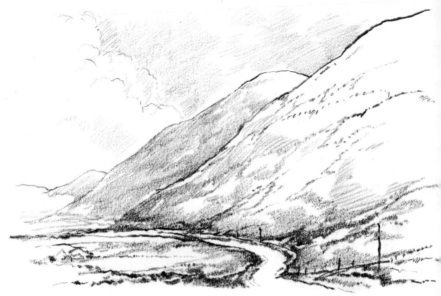

Here the cumulus cloud formation balances the successive slopes of the mountain range

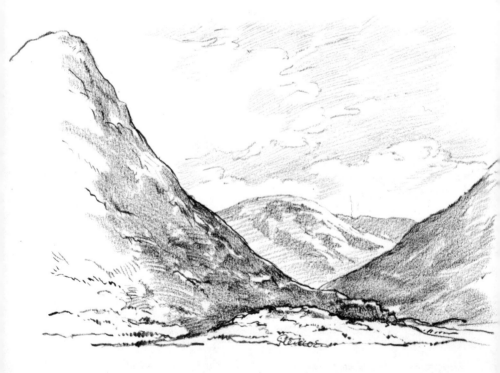

The central mountain is cupped by the opposing hill forms which establish its height and distance

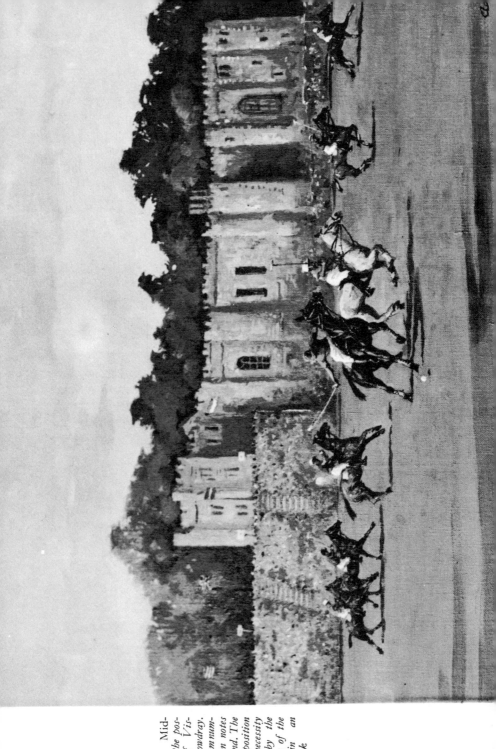

Polo at Midhurst in the possession of Viscount Cowdray. Painted from numerous action notes on the ground. The final composition was of necessity governed by the positioning of the players in an attack

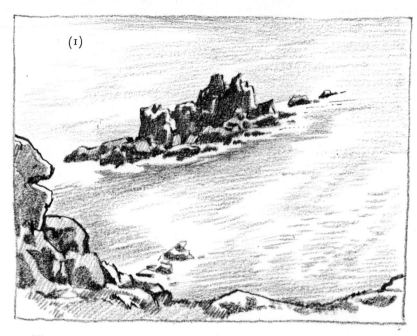

The horizon line is above the top of the picture to convey the effect of looking down

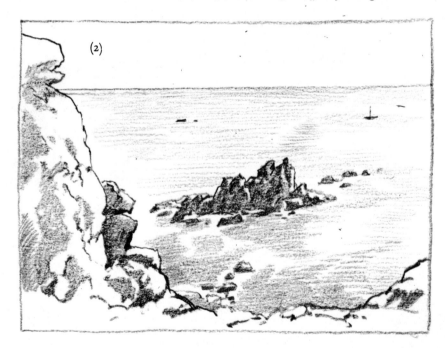

The horizon line is introduced as high as possible and interest is centred on the broken line of the rocks

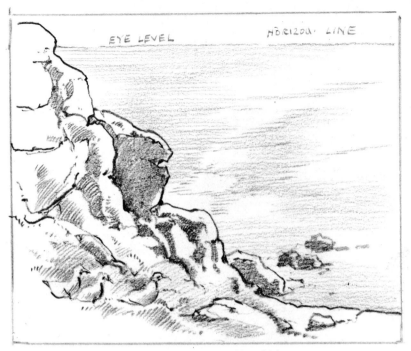

A compromise between (1) and (2)

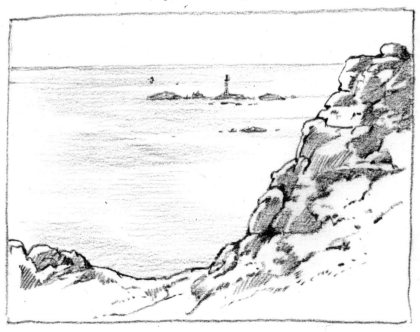

Change of position, introducing lighthouse as a focal point

COMMON MISTAKES

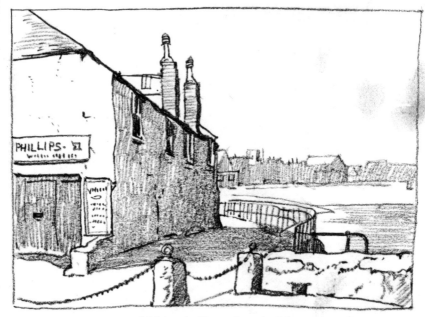

Lighting should come from the right

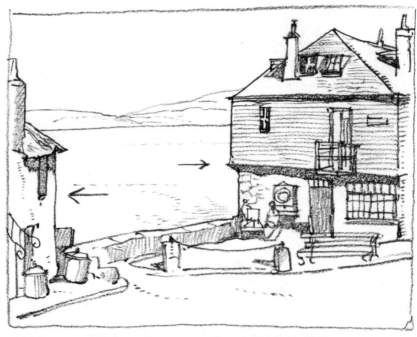

Incidents lacking in the water. Eye directed across from left to right

ARTIST'S CHOICE

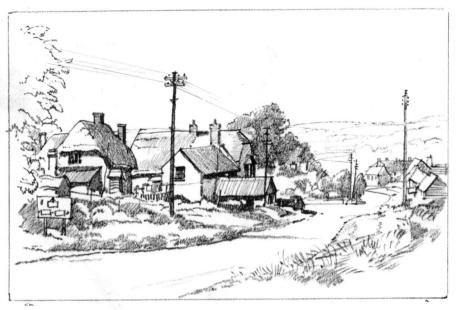

The telegraph poles were standing where they are drawn. Are they needed?

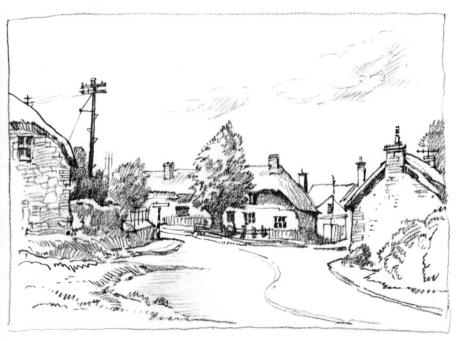

Is the telegraph pole vital to the balance of the composition?

DIRECTION . . .

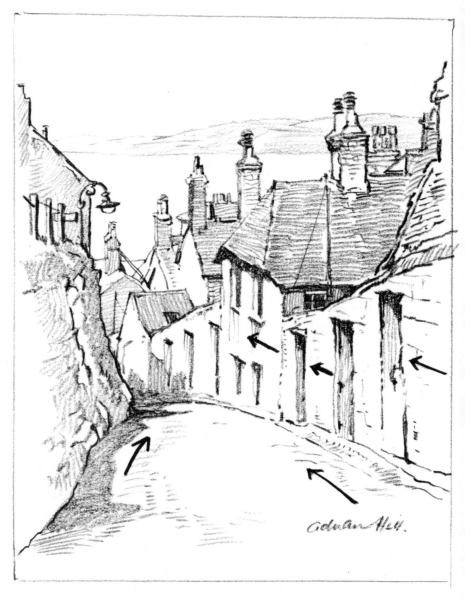

Looking down a steep road. Note direction of arrows

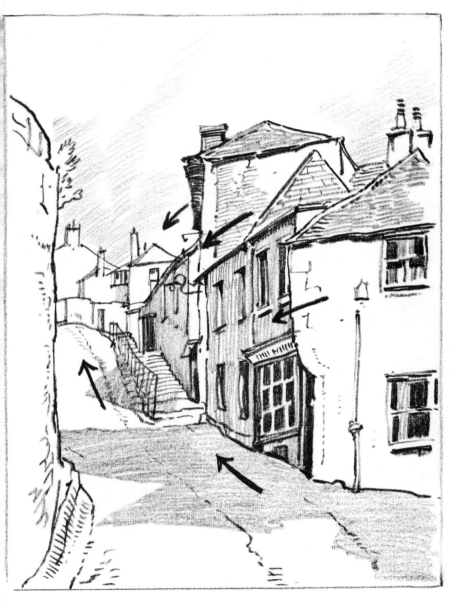

Looking up a steep road. Note the direction of arrows

Summing Up

TO the would-be painter in oils who has digested the contents of this little book, I would like to add a brief postscript. It is simply this:

Oil painting is a plastic medium. Don't be afraid of using plenty of colour. Enjoy the physical act. It is half the joy.

Don't worry your painting so that it loses its first freshness.

Don't take everything in this book as gospel.

Try above all to improve and develop your way of painting and don't labour to emulate somebody else's technique.

Then, and then only, the art activity will always remain an exciting and rewarding adventure.

And to all those who are now embarking—*bon voyage!*

Adrian Hill